emily carr

& her dogs

flirt, punk & Loo

WRITTEN *and* ILLUSTRATED *by* **EMILY CARR**

DOUGLAS & McINTYRE
Vancouver/Toronto/Berkeley

D0770933

Copyright © 1997, 2002 by Douglas & McIntyre
First paperback edition published in 2005
Emily Carr & her dogs was first printed under the title *Flirt, Punk & Loo*

05 06 07 08 09 5 4 3 2 1

All rights reserved. No part of this book may be reproduced, stored in
a retrieval system or transmitted, in any form or by any means, without
the prior written consent of the publisher or a licence from The Canadian
Copyright Licensing Agency (Access Copyright). For a copyright licence,
visit www.accesscopyright.ca or call toll free to 1-800-893-5777.

Douglas & McIntyre Ltd.
2323 Quebec Street, Suite 201
Vancouver, British Columbia
Canada V5T 4S7
www.douglas-mcintyre.com

Library and Archives Canada Cataloguing in Publication
Carr, Emily, 1871–1945
 Emily Carr & her dogs
 Previously published under title: Flirt, Punk & Loo.
 ISBN 1-55054-764-X (bound) 1-55365-095-6 (pbk.)

 1. Carr, Emily, 1871–1945. 2. Old English sheepdog—British Columbia—
anecdotes. 3. Kennel owners—British Columbia—Biography. I. Carr, Emily,
1871–1945. Flirt, Punk & Loo. II. Title. III. Title: Emily Carr and her dogs.
ND249.C3A3 2002 636.737 C2001-911652-7

Library of Congress information is available upon request.

Design by Rose Cowles
Cover drawing by Emily Carr from *Billie's Calendar,*
courtesy of the British Columbia Archives
Printed and bound in Canada by Friesens on acid-free paper
Distributed in the U.S. by Publishers Group West

We gratefully acknowledge the financial support of the Canada Council
for the Arts, the British Columbia Arts Council, and the Government
of Canada through the Book Publishing Industry Development Program
(BPIDP) for our publishing activities.

The stories in this book first appeared as the section entitled "Bobtails"
in the book *The House of All Sorts by Emily Carr.*

Billie's Calendar is reproduced courtesy of the British Columbia Archives.

To My
sister Alice

I think I could turn
and live with animals,
they're so placid
and self-contain'd,
I stand and look at them
long and long.

From Walt Whitman's
Song of Myself

JANUARY OUR STUDIO REOPENS
AFTER XMAS VACATION – ALL FEEL
AFTER-XMASSY AND ROTTON, –
MISSUS AND I HEADACHES, THE FOOL
PARROT GIRLS COLDS, AND THE
PUPILS PARTY-BEDRAGGLED AND
PEEVISH.

DONT THINK MUCH OF XMAS:
DONT THINK MUCH OF ANYBODY:
DONT THINK ANY OF US WILL LIVE
LONG ANY WAY: WHATS THE GOOD
OF ANYTHING: MEN ARE BRUTES,
LEAST WAYS C.P.R. MEN: PUTTING
DOGS DOWN ON COLD RHUMATIC
WIND-SWEPT LOWER DECKS, WHEN
THEY TRAVEL WITH THEIR MISSUSES
HOLIDAYING — BIT THE POST-MAN
AND FEEL BETTER NOW.

Kennel

The idea of a Bobtail kennel did not rush into my mind with a sudden burst. It matured slowly, growing from a sincere love of and admiration for the breed, awaked by my dog, Billie, a half-bred Old English Bobtail Sheep-dog. Billie's Bobtail half was crammed with the loyalty, lovableness, wisdom, courage and kindness of the breed. His something-else half was negligible, though it debarred him from the show bench. Heart, instincts, intelligence—all were pure Bobtail.

When Billie was offered as a gift to me, I refused him, not because of his being cross-bred but because of circumstances. Billie magnificently ignored my refusal and gave himself to me in the wholesome, wholehearted way a Bobtail's devotion works. It was not the easily transferable love of a puppy, for Billie was then three years old. He had the reputation of being wicked and had several bites to his discredit.

First I bathed Billie, then I beat him for killing a chicken—this

only glued his self given allegiance to me the tighter.

He was mine for thirteen years. When he died at the age of sixteen he left such a blank that the Bobtail kennel idea, which had been rooting in me those many years, blossomed. The question was where to obtain stock. There were only a few Bobtails in Canada, brought out as "settlers' effects" from the Old Country. Their owners would as soon have thought of selling their children as their Bobtails. Some of these dogs were excellent specimens, but they were unregistered because the settlers had not bothered to enter them in the Canadian live-stock records at Ottawa, and after a generation or so had elapsed the puppies of these dogs were not eligible for registration.

After long searching I located a litter of Bobtails on a prairie farm and sent for a female puppy. I named her Loo.

Loo was a sturdy puppy of good type and the beautiful Bobtail-blue. The next step was to locate a sire. Friends of mine on a farm up-island had a Bobtail for stock work—a good dog. They mated him to a Bobtail bitch on a neighbouring farm. I never saw the so-called Bobtail mother, but the puppies from the mating were impossible. My friends gave me one.

Intelligence the pup had and a Bobtail benevolent lovableness had won him the name of "Mr. Boffin." But he had besides every

point that a Bobby should not have—long nose, short, straight hair, long, impossible tail, black-and-white colour. I bred Loo to a butcher's dog, a Bobtail imported from England—well-bred, powerful, of rather coarse type but intelligent.

The butcher came to select a puppy from Loo's litter. Dangling his choice by the scruff, he said, "Work waitin', young fella. Your dad was killed last week."

The man sighed—set the pup down gently.

"Shouldn't put a pup to cattle much under a year," he said, and, looking down, saw Boffin standing beside me. Boffin had eased the dog-field gate open and come to me unbidden.

"Go back, Boffin!" I pointed to the gate. The dog immediately trotted back to his field.

"What breed is that dog?"

"Supposedly a Bobtail."

"Bobtail nothin'—I want that dog," said the butcher.

"Not for sale."

"You can't sire a Bobtail kennel by him; 'twouldn't be fair to the breed."

"Don't intend to. That dog is my watch and companion."

"Companion fiddlesticks! That dog wants to work. I *want* that dog."

"So do I. . . . Hen, Boffin!" I called.

From the field Boffin came and with steady gentleness persuaded the hen from the garden back into her yard.

"I want that dog," the butcher repeated and, taking Boffin's head between his hands, looked into the dog's face. "I want him for immediate work."

"He is untrained."

"He knows obedience. Instinct will do the rest. That dog is just crazy to work. Be fair to him—think it over."

I did think—but I wanted Boffin.

At dusk that night a boy came with a rope in his hand. "Come for the dog."

"What dog?"

"The one my father saw this morning—this fella I guess."

Boffin, smelling cow-barn on the boy's clothes, was leaping over him excitedly.

"We drive cattle up-island tomorrow at dawn," said the boy and threw an arm about the dog.

My Boffin, happy till then in rounding up one hen! My Boffin

behind a drove of cattle! How mad—joyful he'd be! I slipped the rope through Boffin's collar, handed it to the boy. He persuaded gently. Boffin looked back at me.

"Go, Boffin!"

The smell of cow was strong, exciting his herding instincts. Boffin obeyed.

Splendid reports came of Boffin's work. I did not go to see him till six months were past, then I went. His welcome of me was overwhelming. The dog was loved and was in good shape. He stuck to my side glue-tight. We stood in the barnyard on the top of the hill. Suddenly I felt the dog's body electrify, saw his ears square. Sheep-bells sounded far off; Boffin left my side and went to that of his new master.

"Away then, Boffin!"

The man waved an arm. The dog's lean, powerful body dashed down the hill. When the dust of his violence cleared, a sea of dirty white backs was wobbling up the hill, a black-and-white quickness darting now here, now there, straightening the line, hurrying a nibbler, urging a straggler. Soberly Boffin turned his flock into their corral, went to his master for approval, then rushed to me for praise.

I was many blocks past the butcher's when I sensed following.

"Boffin!"

I had seen them shut Boffin behind a six-foot fence when I left the butcher's. The wife had said, "Father, shut Boffin in. He intends to follow."

It hurt me to return him, but I knew the job that was his birthright must prevail. . . . ✘

FEBRUARY:

ALL BETTER AND SETTLED SQUARE DOWN TO OUR ROUTINE WORK — LOTS OF POSING TO BE DONE: I WONDER WHAT I REALLY LOOK LIKE, SOME OF THEIR PICTURES MAKE ME FEEL A GOOD BIT POORLY.

Punk

Loo's strong, beautiful pups found a ready market. A soldier in Victoria owned a fine Old English Bobtail Sheep-dog. When he went to the war his Bobtail was desolate. I heard of the dog and went to the soldier's house, saw the shaggy huddle of misery watching the street corner around which his master had disappeared. I knocked on the house-door; the dog paid no heed, as if there was nothing now in that house that was worth guarding. A woman answered my knock.

"Yes, that is my husband's dog, 'Punk,' sulking for his master—won't eat—won't budge from watching that street corner."

A child pushed out of the door past the woman, straddled the dog's back, dug her knees into his sides and shouted, "Get up, Punk."

The dog sat back on his haunches, gently sliding the child to the ground—she lay there kicking and screaming.

"Will you sell the dog?" I asked.

"I cannot; my husband is ridiculously attached to the creature."

I told the woman about wanting to start a Bobtail kennel and my difficulty in locating a sire.

"Take Punk till my husband returns. I'd gladly be rid of the brute!"

I went to the dog. After tipping the child off he lay listless.

"Punk!"

Slowly the tired eyes turned from watching the street corner and looked at me without interest.

"He will follow no one but his master," said the woman.

The dog suffered my hand on his collar; he rose and shambled disheartenedly at my side, carrying the only luggage he possessed—his name and a broken heart.

"Punk!" Not much of a name to head a kennel! But it was the only link the dog had with his old master; he should be "Punk" still.

Loo cheered the desolation from him slowly. Me he accepted as weariness accepts rest. I was afraid to overlove Punk, for fear the woman, when she saw him washed, brushed, and handsome, might want him back. But when I took him to see her, neither dog nor woman was pleased. He followed me back to my house gladly.

Punk and Loo made a grand pair, Loo all bounce, Punk gravely dignified. They were staunchly devoted mates.

My Bobtail kennel throve; the demand for puppies was good. The

government was settling returned soldiers on the land. Land must be cleared before there was much stock-work for sheep and cattle dogs. But Bobtails were comradely; they guarded the men from the desperate loneliness in those isolated places.

Punk had been with me a year. He loved Loo and he loved me; we both loved Punk. I came down the outside stair of my house one morning and found a soldier leaning over my lower landing, hands stretched out to the dogs in their field. Punk was dashing madly at the fence, leaping, backing to dash again, as breakers dash at a sea-wall. The woman who had lent me Punk and the child who had tormented him were beside the man.

"You have come for him?"—my heart sank.

The man's head shook.

"I shall be moving about. Keep him—I am glad to see him happy."

He pushed the hair back from the dog's eyes and looked into them.

"You were comfortable to think about over there, Punk." The man went quickly away.

Parting from his master did not crush Punk this time; he had Loo and he had me. ✗

Beacon Hill

In the early morning the dogs burst from their sleeping quarters to bunch by the garden gate, panting for a race across Beacon Hill Park. Springs that had wound themselves tighter and tighter in their bodies all night would loose with a whirr on the opening of the garden gate. Ravenous for liberty, the dogs tore across the ball grounds at the base of Beacon Hill, slackened their speed to tag each other, wheeled back, waiting to climb the hill with me.

The top of Beacon Hill was bare. You could see north, south, east and west. The dogs rested, tongues lolling, while I looked at the new day, at the pine trees, at the sky, at the sea where it lay flat, and at the broom bushes drooped with early morning wetness. The song of the meadow-lark crumbled away the last remnants of night—three sad lingering notes followed by an exultant double chuckle that gobbled up the still-vibrating three. For one moment the morning took you far out into vague chill, but your body snatched you back into its cosiness,

back to the waiting dogs on the hill top. They could not follow out there, their world was walled, their noses trailed the earth. What a dog cannot hear or smell he distrusts; unless objects are close or move he does not observe them. His nature is to confirm what he sees by his sense of sound or of smell.

"Shut that door! Shut that door!" staccato and dictatorial shouted the voice of the quail as they scuttled in single file from side to side of the path, feet twinkling and slick bodies low-crouched. The open-mouthed squawks of gulls spilled over the sea. From behind the Hill came the long resentful cry of the park peacock, resentful because, having attained supreme loveliness, he could push his magnificence no further.

Pell-mell we scampered down the hillside. A flat of green land paused before letting its steepness rush headlong down clay cliffs. The sea and a drift-piled beach were below. Clay paths meandered down the bank. They were slippery; to keep from falling you must lodge your feet among the grass hummocks at the path-side. The dogs hurled their steady four-footed shapes down the steepness, and awaited me on the pebbly beach. Sea-water wet their feet, wind tossed their hair, excitement quivered in every fibre of their aliveness.

On our return the house was waking. The dogs filed soberly under yet blinded windows, mounted three steps to the landing, sank three

steps to the garden, passed into their play-field, earnest guardians of our house. I went to my daily tasks.

Whenever the Bobbies heard my step on the long outside stair, every body electrified. Tongues drew in, ears squared, noses lifted. The peer from all the eyes under all the bangs of crimpy hair concentrated into one enormous "looking," riveted upon the turning of the stair where I would first show. When I came they trembled, they danced and leapt with joy, scarcely allowing me to squeeze through the gate, crowding me so that I had to bury my face in the crook of an arm to protect it from their ardent lickings, their adoring Bobtail devotion. ✗

The Garden

The garden was just ordinary—common flowers, everyday shrubs, apple-trees. Like a turbulent river the Bobtails raced among gay flowers and comfortable shrubs on their way from sleeping-pen to play-field, a surge of grey movement weaving beautiful patterns among poppy, rose, delphinium, whose flowers showed more brilliantly colourful for the grey intertwistings of shaggy-coated dogs among them.

In the centre of the lawn grew a great cherry-tree better at blossoming than at fruiting. To look into the heart of the cherry-tree when it was blossoming was a marvel almost greater than one could bear. Millions and millions of tiny white bells trembling, swaying, too full of white holiness to ring. Beneath the cherry-tree the Bobbies danced—bounding, rebounding on solid earth, or lying flat in magnificent relaxation.

East, west, north the garden was bounded by empty lots; its south-

ern limit was the straight square shadow of my apartment house.

The depth and narrowness of my lot made the height above it seem higher, a height in which you could pile dreams up, up until the clouds hid them. ✘

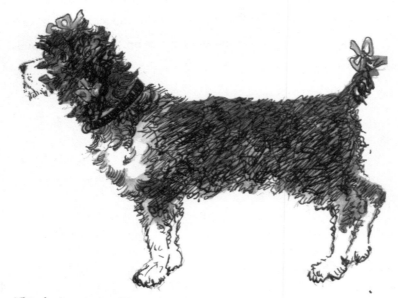

IN MARCH : COMES OUR SPRING
EXHIBITION — DELIGHTFUL
OCCASION WHEN ONCE THE
PRELIMINARY TUBBING IS OVER:
BOWS ON MY HEAD TAIL AND

EVERY WHERE: EVERY ONE SAYS
I'M TOO CUTE FOR ANYTHING:
I HELP MISSUS ENTERTAIN THE
FOLKS: MEET EVERYONE AT
STAIR-HEAD AND WAG TAIL!
EVERY ONE SAYS MY PORTRAITS
ARE "SWEET"

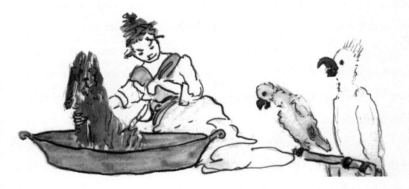

Sunday

Religious people did not know more precisely which day was Sunday than did my Bobtails. On Sunday the field gate stood open. Into the garden trooped a stream of grey vitality, stirring commotion among the calm of the flowers. The garden's Sunday quiet fastened almost immediately upon the dogs. In complete abandon their bodies stretched upon the grass, flat as fur rugs. You could scarcely tell which end of a dog was head and which tail, both were so heavily draped in shagginess. At the sound of my voice one end lifted, the other wobbled. Neither could you tell under the mop over his eyes whether the dog slept or woke—in sleep he was alert; awake, he was dignified, intent.

When Sunday afternoon's quiet was broken by five far-off strokes of the town clock, we all sprang for the basement. In the entrance hall was a gas-ring; on it stood a great stew-pot. There was also a tap and a shelf piled with dinner pans. The dogs ranged themselves along the

basement wall, tongues drawn in, ears alert. I took the big iron spoon and served from the stew-pot into the dinner pans. As I served I sang—foolish jingles into which I wove each dog's name, resonant, rounded, full-sounding. Each owner at the sound of his own name bounced and wobbled—waiting, taut, hoping it would come again.

The human voice is the strongest thing a dog knows—it can coax, terrify, crush. Words are not meaning to a dog. He observes the lilt, the tone, the music—anger and rebuke have meaning too and can crush him. I once had a stone-deaf dog and once I had one that was stone-blind. The deaf dog had nothing to respond to but the pat of pity. She could only "watch"; at night her world was quite blank. The blind dog's blackness was pictured with sounds and with smells. He knew night-scents and night-sounds from day-scents and day-sounds; he heard the good-natured scuffle of dog-play, barkings, rejoicings; he heard also the voice of the human being he loved. The blind dog's *listening* life was happy. The deaf dog's only happiness was to be held close and warm—to feel. ✘

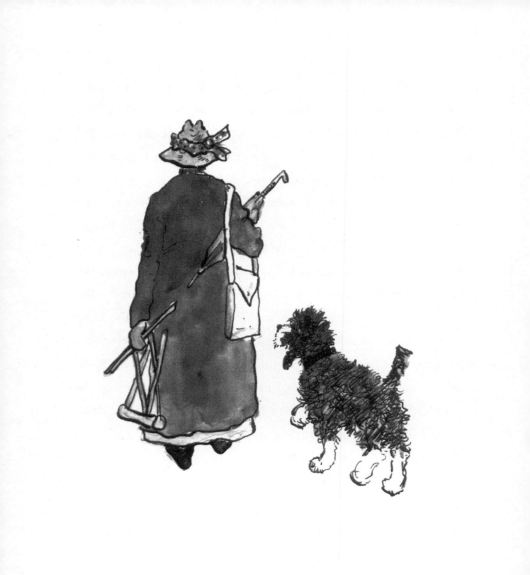

IN APRIL: MISSUS GOES
SKETCHING BETWEEN THE
SHOWERS OF COURSE I GO
TOO TO TAKE CARE OF HER
IT'S LOVELEY JUST WE TWO
ONE TIME THE FOOL PARROTS
GET LEFT.
SLACK MONTH MISSUS
FINDS TIME TO GIVE AN
OVERABUNDANCE OF
TUBS. UGH!

Puppy Room

The puppy room in the basement brimmed with youngness, with suckings, cuddlings, lickings, squirmings—puppies whose eyes were sealed against seeing, puppies whose ears were sealed against hearing for the first ten days of life, puppies rolling around in their mother's box like sausages, heaving in the middle and with four legs foolishly sticking out sideways, rowing aimlessly and quite unable to support the weight of their bodies.

Some Bobtails are born entirely tailless, some have tails which are docked at the age of three days, some have stumps, some twists.

Loo was never happy with a new family until she had brought Punk in to inspect it. Punk lumbered behind his mate, nosed into her box, sniffed and ambled out again, rather bored. It satisfied Loo. The other Bobtail mothers never brought Punk to see their families, but Loo was Punk's favourite mate.

Bobbies have large families—nine is an ordinary litter. Once Flirt

had fourteen pups at one birth. I never allowed a mother to raise more than six pups unaided. If the demand was good I kept more, but I went round the family three times a day with a feeding bottle so that all the pups were satisfied and my mothers not overtaxed. One spring thirty pups were born in the kennel nursery within one week. It took me three hours a day for three weeks "bottling" pups, but they throve amazingly. Sometimes a pup was stubborn and would not take the bottle; then I tickled him under the chin; this made him yawn and I popped the bottle into his yawn and held it there till he sucked. The mothers watched me with great interest; my yawn method was a joke between us. They were most grateful for my help, those patient, loving dog mothers. ✗

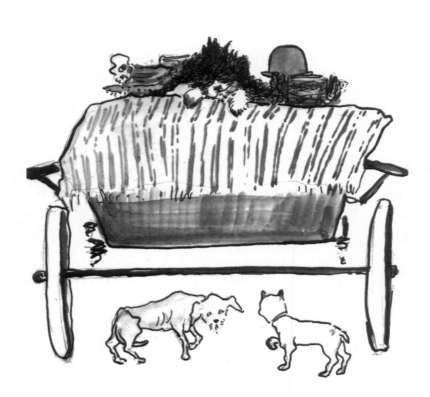

MAY. OUR FRIEND 'THE INSPECTOR'
MAKES HIS ANUAL TOUR WEST:
SPLENDACIOUS OCCASION:
ICE CREAN IN RESTURANTS, (NOT
STOLEN EITHER) SPECIAL DOUBLE
ORDER FOR "THE DOG" (THATS ME):
ALL THE MACKINTOSHE'S TOFFE
I CAN EAT: AND DRIVE IN
THE PARK : WHERE I CAN
LOOK DOWN AND JEER AT
THE PEDESTRIAN CURS.

Poison

The butcher lifted half a pig's head to his nose, sent it flying with a disgusted hurl into the bundle of scrap that Bobtail Meg was waiting to carry home in her saddle-bags for the kennel. Meg loved to lug the butcher-scraps home for me. When her saddle-bags were filled Meg rose, shook butcher-floor sawdust from her coat and waddled the bones away with pompous pride. Meg never was so happy as when she was busy.

There was something sinister in that pig's one eye when I stuck his half-head into the dog-pot. It made the soup into a rich, thick jelly and smelled good.

Flirt, Loo's daughter, had a litter two weeks old. Flirt was ravenous and gobbled a generous portion of soup and meat. The next day a pup was sick, others were ailing. The veterinary ran a stubby finger around the sick pup's gums. "Teething," he said, and, taking a pocket knife, slashed the pup's gums, wiped the knife on his pants and

rammed it into his pocket along with my two dollars. That night the pup died. I was furious—puppies never bothered over teething! I called another veterinary. "Poison," said the old man, and I remembered the butcher's nose and the pig's eye. This vet shook his head and killed the sickest pup to prove his diagnosis by post mortem. He said, "This is a matter for nursing not doctoring. I think all of them will die."

Every pup was bespoken. I did not want them to die and the pups wanted to live—they put up a good fight and won.

I took them away from Flirt. They were too listless to suck a bottle. I spooned brandy and milk down their throats, and to the amazement of the veterinary reared the entire litter. The runt was the grittiest pup of all; for days he writhed out of one convulsion into the next—calmed from one only to go through it all over again. One morning before dawn I found him stiff, tongue lolling, eyes glazed. I had for several days *almost* decided to put an end to his misery. From force of habit I trickled brandy over the lolling tongue—no response. A grave to dig in the morning! Dazed with tiredness I put the pup into his basket and went back to the garden room where I was sleeping during the poison trouble so that I might watch over the puppies. Sticking basket and feeding-bottle into a far corner of the room I tumbled into bed.

The sun and a queer noise woke me. I peeped overboard to see the

runt seated on the floor in a patch of sunshine, the feeding-bottle braced between his paws, sucking with feeble fury.

I cried, "You gritty little beast!", warmed his milk and a hot-water bottle, tucked him into his basket and named him "Grits."

Grits turned into a fine and most intelligent dog. He was sold and sent as a love-gift to a man's sweetheart in Bermuda. Another of that poisoned litter went to France, pet of a wealthy man's children; another to Hollywood, where he saved two children from drowning while sea bathing. He was filmed. But mostly my Bobbies homed themselves in Canada. They won in the local dog shows. I did not show them further afield. To raise prize-winners was not the objective of my kennel. I aimed at producing healthy, intelligent working stock and selling puppies at a price the man of moderate means could afford, yet keeping the price high enough to insure the buyer feeling that his *money's worth* must be given due care and consideration. ✗

Naming

Every creature accepting domesticity is entitled to a name.

It enraged me to find, perhaps a year later, that a pup I had sold was adult and unnamed, or was just called "Pup," "Tyke," or some general name. Were humans so blind that a creature's peculiarities suggested no name special to him?—nothing but a *class* tag? In selling a young pup, the naming was always left to the buyer. If I raised or half-raised a dog, I named him. For my kennel I liked the patriarchs—Noah, Moses, David, Adam. They seemed to suit the grey-bearded, rugged dignity of the Bobbies whose nature was earnest, faithful, dutiful.

At dog shows kennel-men smiled at the names on my entries. They said, "Why not 'Prince,' 'Duke,' 'King'?—more aristocratic!" But I clung to my patriarchs. The Old English Bobtail Sheep-dog is more patriarch than aristocrat. ✘

IN JUNE WE TAKE ALL OUR
PUPILS OUT SKETCHING: MISSUS
MUCH OCCUPIED:
EXCELLENT GLEANINGS
IN NEAR- BY LANE
ASH-BARRELS WHILE KIDS WORK,

ALSO—I HAVE MY SUMMER
CLIPP: BEASTLY PERFORMANCE:
I'D GO MAD AND BITE IF MISSUS

DID NOT KEEP HER HAND ON MY
HEAD ALL THE TIME: IT'S AN
ELECTRIC TORMENT MAKES A
HORRIBLE ROW AND TICKLES ALL
OVER: AND A MAN BRUTE HOLDS
EVERY ONE OF MY LEGS SO I
CANT KICK: BUT THE MOMENT
IT'S OVER! GOLLY IT'S GRAND
AND COOL AND MY FIGURE LOOKS
AWEFULLY GENTEEL: JUST MY
WIG SOCKS AND TAIL LEFT,
THIS IS WHEN J EVEN UP ON
THE FLEAS, AND IF THE OLD
PARROTS LAUGH, I GET IT
BACK ON THEM WHEN THEY
MOULT.

Meg the Worker

Bobtail Meg was registered. I bought her by mail; I sent the money but no dog came. After writing a number of letters which were not answered, I applied to a lawyer. He wrote—Meg came. Her seller claimed that the dog had been run over on the way to be shipped. She was a poor lank creature with a great half-healed wound in her side. I was minded to return her. Then I saw the look in Meg's eyes, the half-healed, neglected wound, and I could not send her back to the kind of home she had obviously come from. I saw too how ravenously she ate, how afraid she was to accept kindness, how distrustful of coaxing.

Her coat was a tangled mass, barbed with last year's burs, matted disgustingly with cow dung. Before I let her go among my own dogs, she had to be cleaned. I got a tub and a pair of shears. When the filth was cleared away Meg shook herself; her white undercoat fluffed patchily, she looked chewed but felt clean and was eased by the dress-

ing of her wound. She felt light-hearted, too, and self-respecting. Before the shears had finished their job Meg had given me her heart.

The kennel accepted Meg; Meg had no ears or eyes for any living thing, beast or human, but me. All day she sat in the dog-field, her eyes glued to my windows or the stair, waiting, trembling to hear my step, to see my shadow pass.

When her coat grew Meg did not look too bad. She was very intelligent and had been taught to work. Idleness irked Meg; her whole being twitched to obey; her eyes pleaded, "Work!" On Beacon Hill she bustled in and out among the broom hunting imaginary sheep and would slink shamedly to my heel when she failed to find any.

I invented work for Meg. I was clearing the smaller stones off the far field, Meg following my every trip to a far corner where I emptied my basket. I stitched a pair of saddle-bags and bound them on to Meg. The dog stood patiently while I filled them with small stones and then trotted them to the dumping place proudly. I took her and her saddle-bags to the butcher's for the daily kennel rations. Meg lugged them home, nose high when she passed the dog-field where the others sniffed enviously. The bone that was her reward did not please Meg much, she let the others take it from her. Had any of them taken her job, Meg's heart would have been broken.

A kind-voiced man rushed into the kennel one day.

"I want a trained, cattle-dog to take with me to the Cariboo immediately!"

He fancied Meg; I liked the way he handled her. I let Meg go to the big spaces and the job that was hers by right. ✗

Basement

Creeping around a basement in the small dark hours is not cheerful. A house's underneathness is crushing—weight of sleep pressing from the flats above, little lumps of coal releasing miniature avalanches which rattle down the black pile, furnace grimly dead, asbestos-covered arms prying into every corner.

Just inside the basement door was a yawn of black. This portion of basement was uncemented, low-ceiled, earthy, unsunned. Often in daytime I must creep here among the cobwebs to feel hot-air-pipes and see that each tenant got his just amount of heat. Ghastly white pipes twisted and meandered through the dimness. A maple stump was still rooted here. Every year it sprouted feebler, paler shoots, anaemic, ghastly! Punk kept bones under the hollow of this old root. At night when we went down to tend puppies or sick dogs I scuttled quickly past the black. Cobwebby darkness did not worry Punk; he dashed in and dug up a bone to gnaw while I tended puppies. ✗

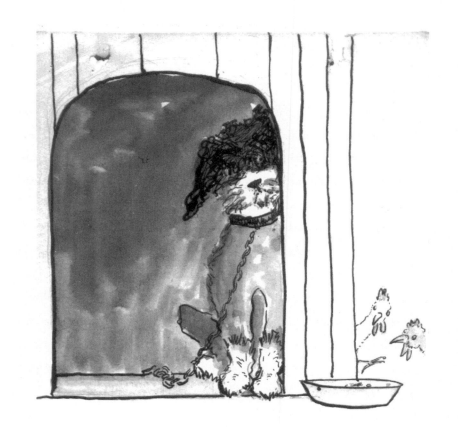

JULY: THE BLACKEST MONTH
IN MY CALLENDAR: WE VISIT
MY AUNT KAISER: CHAINED TO A
WRETCHED KENNEL, AND JEERED
AT BY CURS MIKE AND BEN:
DREADFULLY BORED: ENTICE
FOULS INTO KENNEL AND SLAY
THEM: AWEFUL WHACKINGS!!
GET LOOSE AND TEAR OLD BEN
ALMOST TO BITS: GET BUNGED
EYE AND MORE WHACKS: HEART
ALMOST BROKEN: MISSUS
SNEAKS ME UP TO HER ROOM
AND CUDDLES ME: OH MISSUS
MISSUS LET'S GO HOME TO
THE STUDIO.

Night

Many a winter night Punk, who slept upstairs in my flat, and I crept down the long outside stair to the basement, sometimes crunching snow on every step, sometimes slipping through rain. Old moon saw us when she was full. When new, her chin curled towards her forehead and she did not look at us. The corners of the stairway were black. Sometimes we met puffs of wind, sometimes wreaths of white mist. It was comfortable to rest a hand on Punk, envying his indifference to dark, cold, fear. I envied Punk his calm acceptance of everything. ✗

The Dog-Thief

I loved sleeping in the garden room, my garden room where flowers and creatures were so close.

It was nearly time for the moon to turn in and for me to turn out. Punk, lying on the mat beside my bed, got up, crept to the open door—stood, a blurred mass of listening shadow.

The blind man in my downstairs flat had twice before told me of rustlings in the dog-field at night. His super-sensitiveness had detected fingers feeling along the outer wall of his flat.

"I think," he had suggested, "that someone is after a pup."

I threw on a gown and stood beside Punk. The shadow by the pup-house door looked, I thought, unusually bulky. Punk and I went down the cinder path. Punk growled, the shadow darted behind the lilac bush, uttering a high sing-song squeal. There was light enough to show Chinese cut of clothes—I heard the slip-slop of Chinese shoes.

"What do you want?"

"Me loosed," he whined.

"You are not lost. You came in by my gate. Put him out, Punk!"

Whites of slant, terrified eyes rolled as the dog allowed him to pass but kept at his heels until he was out in the street. Whoever bribed that Chinaman to steal a pup had not reckoned on Punk's being loose, nor had he counted on my sleeping in my garden. ✗

Selling

A stranger stood at the garden gate. Young dogs leapt, old dogs stiffened and growled, enquiring noses smelled through the bars of the gate at the head of the garden steps. Fore-paws rested a step higher than hind-paws, making dogs' slanted bodies, massed upon the steps, look like a grey thatch. Strong snuffing breaths were drawn in silently, expelled loudly.

I came into the middle of the dog pack and asked of the stranger, "You wanted something?"

The man bracketed dogs and me in one disdainful look.

"I want a dog."

The coarse hand that swept insolently over the dogs' heads enraged them. They made such bedlam that an upper and a lower tenant's head protruded from the side of the house, each at the level of his own flat.

"What price the big brute?"—indicating Punk.

"Not for sale."

"The blue bitch?"—pointing to Loo.

"Not for sale."

"Anything for sale?" he sneered.

"Puppies."

"More bother'n they're worth! . . . G'ar on!"

He struck Punk's nose for sniffing at his sleeve.

"D'you want to sell or d'you not?"

"Not."

The man shrugged—went away.

Money in exchange for Bobbies was dirty from hands like those. ✘

Kipling

The dogs and I were Sundaying on the garden lawn. Suddenly every dog made a good-natured rush at the garden gate. A man and a woman of middle age were leaning over it. The dogs bunched on the steps below the gate. The woman stretched a kindly hand to them. The man only stared—stared and smiled.

"Were you looking for somebody?" I asked.

"Not exactly—he," the woman waved a hand towards the man, "has always had a notion for Bobtails."

I invited them into my garden.

"Would you like to see the pups?" I said, and led the way to the puppy pen. The woman leant across, but the man jumped over the low fence and knelt on the earth among the puppies.

"Your 'Sunday,' Father!" reminded the woman.

He gave a flip to his dusty knees, but continued kneeling among scraping, pawing pups. Picking up a sturdy chap, he held it close.

"Kip, Kip," he kept saying.

"Kipling and Bobtails is his only queerness," the woman apologized.

"I suppose they are very expensive?" the man said, putting the puppy down on the ground. To the pup he said, "You are not a necessity, little fellow!" and turned away.

"There's times *wants* is *necessities*, Father," said the woman. "You go ahead and pick. Who's ate them millions and millions of loaves you've baked these thirty years? Not you. Jest time it is that you took some pleasure to yourself. Pick the best, too!"

With shaking hand the baker lifted the pup he had held before, the one he had already named Kip. He hurried the puppy's price out of his pocket (Ah! He had known he was going to buy!), crooked one arm to prevent the pup from slipping from beneath his coat, crooked the other arm for his wife to take hold. Neither of them noticed the dust on his "Sundays" as they smiled off down the street.

Sales like this were delicious—satisfactory to buyer, seller, dog. ✘

Lorenzo Was Registered

Only once did I come upon a Bobbie who was a near-fool; he was a dog I bought because of his registration, for I went on coveting registration for my dogs. Lorenzo was advertised: "A magnificent specimen of the noble breed—registered name—'Lorenzo.'" He was impressive enough on paper; in the flesh he was a scraggy, muddle-coloured, sparse-coated creature, with none of the massive, lumbering shagginess of the true Bobbie. His papers apparently were all right. His owner described the dog as "an ornament to any *gentleman's* heel." I wanted dignity of registration for my kennels, not ornament for my heels.

Lorenzo had acquired an elegant high-stepping gait in place of the Bobtail shamble, also a pernickety appetite. He scorned my wholesome kennel fare, toothing out dainties and leaving the grosser portions to be finished by the other dogs.

Lorenzo was mine for only a short time. I had a letter asking for a dog of his type from a man very much the type of Lorenzo's former

owner. The letter said, "I have a fancy for adding an Old Country note to my Canadian farm in the shape of an Old English Bobtail Sheep-dog. I have no stock to work, but the dog must be a good heeler—registration *absolutely necessary*."

High-stepping Lorenzo was in tune with spats and a monocle, was registered and a good heeler. I told the man I had better-type dogs unregistered, but a check came by return emphatically stating that Lorenzo was the dog for him.

Lorenzo's buyer declared himself completely satisfied with foolish, high-stepping, bad-typed Lorenzo—Lorenzo was registered. ✗

Sissy's Job

The earth was fairly peppered with David Harbin's cousins. No matter what part of the world was mentioned David said, "I have a cousin out there." David was a London lawyer. During law vacation he visited cousins all over the world. He always came to see me when visiting Canadian cousins.

David and I were sitting on my garden bench talking. David said, "My last visit (to a Canadian cousin) has left me very sad. Cousin Allan and I were brought up together; his parents died and my Mother took Allan. He was a deaf-mute. His dumbness did not seem to matter when we were boys. We used dumb language and were jolly. When Allan had to face life, to take his dumbness out into the world, that was different—he bought a ranch in Canada, a far-off, isolated ranch. Now he is doubly solitary, surrounded by empty space as well as dead silence."

While David talked a Mother Bobtail came and laid her chin on his knee. His hand strayed to her head but he did not look at her. His see-

ing was not in the garden; it was back on the lonely ranch with dumb Allan. The dog sensed trouble in David's voice, in his touch she felt sadness. She leapt, licked his face! David started.

"Down, Sissy," I called.

But David shouted, "Dog, *you're* the solution. Is she for sale?"

"Sissy," I said, "was intended for a kennel matron. But she was temperamental over her first litter, did not mother them well. She will do better next time perhaps, unless. . . ."

I caught David's eye. . . .

"Unless I send her over to mother dumb Allan!"

David fairly danced from my garden, he was so happy in his solution for Allan's loneliness.

From England he wrote, "Allan's letters have completely changed, despondency gone from them. Bless Bobtails!—Sissy did it." ✗

Min the Nurse

In the public market the butcher's scale banged down with a clank. The butcher grinned first at the pointer, then at me. The meat on the scale was worth far more than I was paying.

"Bobtails," murmured the butcher caressingly—"Bobtails is good dogs! . . . 'Member the little 'un I bought from your kennel a year back?"

"I do. Hope she turned out well—good worker?"

"Good worker! You bet. More sick nurse than cattle driver. Our Min's fine! Y'see, Missus be bed-fast. Market days she'd lay there, sun-up to sun-down, alone. I got Min; then she wan't alone no more; Min took hold. Market days Min minds wife, Min minds farm, Min keeps pigs out of potatoes, Min guards sheep from cougars, Min shoos coon from hen-house—Min, Min, Min. Min runs the whole works, Min do!"

He leaned a heavy arm across the scale, enraging its spring. He wagged an impressive forefinger and said, "Females understands

females." Nod, nod, another nod. "Times there's no easin' the frets of Missus. Them times I off's to barn. 'Min,' I sez, 'You stay,' an' Min stays. Dogs be powerful understandin'."

He handed me the heavy parcel and gave yet another nod.

"Fido's chop, butcher!"

The voice was overbearing and tart; then it crooned down to the yapping, blanketed, wriggling, "Pom" under her arm, "Oo's chopsie is coming, ducksie!"

The butcher slammed a meagre chop on the scale, gathered up the corners of the paper, snapped the string, flung the package over the counter, tossed the coin into his cash box—then fell to sharpening knives furiously. ✗

Babies

The dogs and I were absorbing sultry calm under the big maple tree in their play-field. They sprawled on the parched grass, not awake enough to seek trouble, not asleep enough to be unaware of the slightest happening.

A most extraordinary noise was happening, a metallic gurgle that rasped in even-spaced screeches. The noise stopped at our gate; every dog made a dash. Punk and Loo, who had been sitting on top of the low kennel against which I rested, leaped over my head to join the pack. The fence of their field angled the front gate. A weary woman shoved the gate open with the front wheels of the pram she pushed. A squeal or two and the noise stopped.

The woman drove the baby-carriage into the shade of the hawthorn tree and herself slumped on to the bench just inside my gate. Her head bobbed forward; she was so asleep that even the dogs' barking in her ear and pushing her hat over one eye, pawing and sniff-

ing over the fence against which the bench backed, did not wake her. For a few seconds her hand went on jogging the pram, then dropped to her side like a weighted bag. I called the dogs back and every soul of us drowsed out into the summer hum. Only the sun was really awake. He rounded the thorn-tree and settled his scorch on to the baby's nose.

The child squirmed. He was most unattractive, a speckle-faced, slobbery, scowling infant. A yellow turkish-towelling bib under his chin did not add to his beauty. In the afternoon glare he looked like a sunset. He rammed a doubled-up fist into his mouth and began to gnaw and grumble. The woman stirred in her unlovely sleep, and her hand started automatically to jog the pram handle. I had come from the dog field and was sitting beside her on the bench. Eyes peering from partly stuck-together lids like those of a nine-day-old kitten, she saw me.

"Teethin'," she yawned, and nodded in the direction of the pram; then her head flopped and she resumed loose-lipped, snorting slumber.

"Wa-a-a-a!"

The dogs came inquisitively to the fence.

" 'Ush, 'Ush!"

She saw the dogs, felt their cool noses against her cheek.

"Where be I?—Mercy! I come for a pup! *That's* where I be! 'Usband says when we was changin' shifts walkin' son last night. 'Try a pup, Mother,' 'e sez—'We've tried rattles an' balls an' toys. Try a live pup to soothe 'is frettiness.' So I come. 'Usband sez, 'Git a pup same age as son'—Sooner 'ave one 'ouse-broke me'self—wot yer got?"

"I have pups three months old."

"Ezzact same age as son! Bring 'em along."

She inspected the puppy, running an experienced finger around his gums.

"Toothed a'ready! 'E'll do."

She tucked the pup into the pram beside the baby who immediately seized the dog's ear and began to chew. The pup as immediately applied himself greedily to the baby's bottle and began to suck.

"Well, I never did!" said the mother. "Let 'im finish—'ere's a comfort for son."

She dived into a deep cloth bag.

"That pup was brought up on a bottle," I explained.

"That so? Tote!" she commanded. I operated the pram's screech till the comfort was in the baby's mouth and the pup paid for.

Loo and I, watching, heard the pram-full of baby whine down the street. Loo, when satisfied that the noise was purely mechanical, not

puppy-made, shook herself and trotted contentedly back to the field—finished with that lot of puppies. Nature would now rest Loo, prepare her for the next lot of puppies. Life, persistent life! Always pushing, always going on. ✗

Distemper

Distemper swooped upon the kennel. Dance went from strong, straight legs leaving trembling weakness. Noses parched, cracked with fever, eyes crusted, ears lay limp; there were no tailless, all-over wobbles of joy, anticipation, curiosity; dinners went untouched.

One veterinary advocated open air and cold, the other sweating in a steam-box. I tried every distemper remedy then known. Death swept the kennel. A bucket of water stood always ready beside the garden tap for the little ones. When convulsions set in, I put an end to the pup's suffering. After convulsions started the case was hopeless.

These drowning horrors usually had to be done between midnight and dawn. The puppies yelped in delirium. (Tenants must not be disturbed by dog agony.) In the night-black garden I shook with the horror of taking life—when it must be done, the veterinary destroyed adult dogs that could not recover.

That bout of distemper took the lives of fifteen of my Bobtails, and

took two months to do it in. Creena, a beautiful young mother dog I had just bought, was the last adult to die. The vet took her body away; there was room for no more graves in my garden. Two half-grown dead pups in dripping sacks lay in the shed waiting for dark—of Loo's eight puppies (the ones the Prince of Wales had admired and fondled in the Victoria show a few weeks earlier) only two were left; they were ramping around their box in delirium. I could endure no more. It might be several days yet before they died. I took them to the garden bucket.

Now the kennel was empty except for Loo, Punk and Flirt. We must start all over again. That night when dark came I heaped four dripping sacks into the old pram, in which I brought bones from the butcher's, and trundled my sad load through black, wild storm to the cliffs off Beacon Hill. Greedy white breakers licked the weighted sacks from my hands, carried them out, out.

Punk waited at home. The tragedy in the kennel he did not comprehend—trouble of the human being he loved distressed the dog sorely. Whimpering, he came close—licked my hands, my face for sorrow. ✘

Gertie

The man said, "The garden belongs to my cousins, I board with them."

I could see he minded being only a "boarder," minded having no ground-rights.

The resentful voice continued, "Gertie has outgrown her pen and her welcome."

Pulling a stalk of wild grass, he chewed on it furiously. This action, together with the name of the dog, made me remember the man. A year ago he had come to my kennel. I had been impressed with the hideousness of the name "Gertie" for a dog. He had looked long at Loo's pups, suddenly had swooped to gather a small female that was almost all white into his arms. "This one!" he exclaimed, "daintiest pup of them all!" and, putting his cheek against the puppy, he murmured, "Gertie your name is, Gertie, *Gertie!*" Then he tucked her inside his coat and went sailing down the street, happy.

Now Gertie was up for sale and I was buying her back.

With a squeezing burst Gertie shot through her small door to fling herself upon her master. We stood beside the outgrown pen.

"I made it as big as the space they allowed would permit," giving a scornful glance at the small quarters of the big dog. "All right when she was little. Now it is cruel to keep a creature of her size in it."

Gertie was circling us joyously. Her glad free yelps brought the cousins rushing from their house, one lady furnished with a broom, the other with a duster. One dashed to the pansy-bed waving the duster protectively. The other broomed, militant, at the end of the delphinium row.

"Leash her!" squealed Pansy.

"Leash her!" echoed Delphinium.

The man took a lead from his pocket and secured Gertie. The women saw me take the lead in my hand, saw me put Gertie's price into his. He dashed the money into his pocket without a look, as if it burned his hand to hold it, turned abruptly, went into the house. The duster and the broom limped. The women smiled.

"Destructive and clumsy as a cow!" said Pansy, and scowled as Gertie passed them on her way to the gate, led by me.

"Creatures that size should be banned from city property!" agreed Delphinium with a scowl the twin of Pansy's.

Gertie, her head turned back over her shoulder, came with me submissively to the gate; here she sat down, would not budge. I pushed her out on to the pavement and shut the gate behind her—neither coaxing nor shoving would get Gertie further.

Suddenly there was a quick step on the garden walk—Gertie sprang, waiting for the gate to open, waiting to fling herself upon her adored master, pleading. I let go the lead, busied myself examining blight on the hedge. I was positive the sun had glittered on some unnatural shininess on the man's cheek. He handed me Gertie's lead. "I shall not come to see her. Will you give her the comfort of retaining the sound of her old name? Gertie," he whispered, "Gertie!" and the dog waggled with joy.

Gertie! Ugh, I *loathed* the name—Gertie among my patriarchs!

I said, "Yes, I'll keep the sound."

He commanded, "Go, Gertie."

The dog obeyed, rising to amble unenthusiastically in the direction of his pointing finger and my heels.

Honestly, I "Gertied" Gertie all the way home. Then, taking her head between my hands and bending close said, "Flirtie, Flirtie, Flirtie," distinctly into the dog's ear. She was intelligent and responded just as well to "Flirtie" as to "Gertie." After all, I told myself, it was

the *sound* I promised that Gertie should keep.

The "ie" I gradually lopped off too. Maybe her master had abbreviated to "Gert" sometimes. Flirt became one of the pillars of my kennel.

She was frightened to death of her first puppies. She dug holes in the earth and buried them as soon as they were born. I dug the pups up, restored them to life, but Flirt refused to have anything to do with them. In despair I brought old Loo into the next pen and gave the pups to her. She bathed and cuddled them all day. More she could not do as she had no puppies of her own at that time. At evening when the pups squealed with hunger and Loo was just a little bored, I sat an hour in Flirt's pen reasoning with her. Little by little the terrified, trembling mother allowed her puppies to creep close, closer, finally to touch her.

Her realization of motherhood came with a rush. She gave herself with Bobtail wholeheartedness to her pups, and ever after was a genuine mother. ✗

The Cousins' Bobtails

Two men, cousins, came to buy Bobtails. One cousin was rich and had a beautiful estate; the other was poor and was overseer and cowman for his cousin.

The rich cousin bought the handsomest and highest-priced pup in the kennel. After careful consideration the poor man chose the runt of the litter.

"This pup has brains," he said.

A chauffeur carried the rich man's pup to his car. The poor man, cuddling his puppy in his arm, walked away smiling.

A year later the rich cousin came to see me. He said, "I am entering my Bobtail in the show. I would like you to look him over." He sent his car and I went to his beautiful estate. His dog, Bob, was Loo's pup, well-mannered, handsome. I asked how the dog was for work.

"Well, our sheep are all show-stock, safely corralled. There *is* no work for Bob except to be ornamental. The women folks are crazy

— 63 —

about him, never allow him 'round the barns. My cousin's dog does our cattle work."

We went to the cattle-barns, Bob walking behind us with dignity. The cow-cousin and a burly Bobtail were bringing in the dairy herd. They gave a nod and a "woof" in our direction and continued about their business. When the cows were stalled the man said "Right, Lass!" and man and dog came to where we stood. Wisps of straw stuck in the work-dog's coat, mud was on her feet, she reeked of cow. She stood soberly beside her master paying no heed either to Bob or to us.

"She handles the cows well," I said to the cow-cousin.

"Wouldn't trade Lass for a kingdom!" He directed a scornful eye and a pointing finger towards Bob, muttering, "Soft as mush!"

"Are you entering Lass in the show?"

"Show Lass! Lass has no time to sit on show-benches—on her job from dawn till dark—cows, pigs, hens. Leghorn fowls are pretty flighty you know, but Lass can walk into the midst of a flock—no fuss, just picks out the hen of my pointing, pins the bird to the ground by placing her paw squarely but gently on its back, holds on till I come. She can separate hens from pullets, cajoling each into their right pens—off then to the bushes for those tiresome youngsters that *will* roost in the trees. No peace for bird or beast 'round this farm unless it obeys Lass!"

Bob went to the show. He won "the blue," delighting in the fuss and admiration. Lass at home commanded her pigs, drove hens, plodded after cows, but no fluttering ribbon of blue on Lass's collar could have exalted her Bobtail pride as did "Good girl, Lass!"—her master's voice, her master's praise. ✗

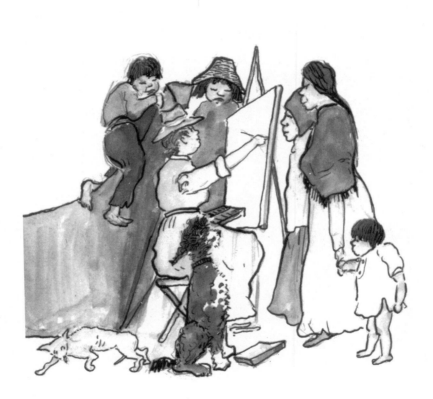

AUGUST: ALL WOES FORGOT; SAIL FOR THE NORTH ON A SKETCHING TOUR: RURAL LIFE: SLEEP UNDER MISSUSES BED: SPEND ALL DAY SKETCHING ROUND INDIAN VILLAGES! RARE SMELLS AND CHOICE PICKINGS OF DRIED FISH: WHIP ALL THE INDIAN CURS: WAKE THE CATS UP A BIT STRIKE TERROR TO THE HEARTS OF THE PAPOOSES AND LEAD THE LIFE OF A COUNTRY GENTLEMAN:

Blue or Red

Her skin was like rag ill-washed and rough-dried. Both skin and clothing of the woman were the texture of hydrangea blossoms—thin, sapless. On exaggeratedly high heels her papery structure tottered.

"I want a dog."

"Work dog or companion?"

"One-o-them whatcher-callum—the kind you got."

"Bobtail Sheep-dogs."

"I ain't got no sheep, jest a husband. Lots younger'n me. I tried to keep my years down to his—can't be done,"—she shrugged.

The shrug nearly sent her thin shoulder blades ripping through the flimsy stuff of her blouse. She gripped a puppy by the scruff, raised him to eye-level, giggled, shook the soft, dangling lump lovingly, then lowered him to her flat chest. She dug her nose into his wool as if he had been a powder puff, hugging till he whimpered. She

put him on the ground, rummaged in a deep woollen bag.

The money was all in small coin, pinches here and pinches there hoarded from little economies in dress and housekeeping. When the twenty-five and fifty-cent pieces, the nickels and the dimes were in neat piles on the garden bench, she counted them three times over, picked up her pup and went away. The silly heels tap-tapped down the garden path. She gave backward nods at the little piles of coin on the bench, each coin might have been a separate lonesomeness that she was saying goodbye to, grateful that they had brought her this wriggling happy thing to love.

A year later I was working in my garden and the little hydrangea person came again. Beside her lumbered a massive Bobtail. When he saw his brethren in the field his excitement rose to a fury of prances and barkings.

"Down, Jerry, down!"

No authority was in the voice. The dog continued to prance and to bark.

"Must a dog on the show bench be chained?"

"Most certainly he must be chained."

"That settles it! Jerry, Jerry, I *did* so want you to win the blue!"

"He is fine," I said.

"Couldn't be beaten, but Jerry will neither chain nor leash!"

"He could easily be taught."

"I dare not; Jerry is powerful. I'd be afraid."

I took a piece of string from my pocket, put it through Jerry's collar, engaged his attention, led him down the garden and back. He led like a lamb.

"See." I gave the string into her hand. The dog pulled back, breaking the string the moment her thin uncertain grasp took hold.

"Leave Jerry with me for half an hour."

She looked dubious.

"You won't beat him?"

"That would not teach him."

Reluctantly she went away. Jerry was so occupied in watching the dogs in the field he did not notice that she was gone. I got a stout lead, tied Jerry to the fence, then I took Flirt and Loo to the far field and ran them up and down. Jerry wanted to join in the fun. When he wanted hard enough I coupled him to Flirt. We all raced. Jerry was mad with the fun of it. Then I led him alone. By the time the woman came back Jerry understood what a lead was. He was reluctant to stop racing and go with his mistress. I saw them head for home, tapping heels and fluttering drapes, hardly able to keep up with the vigorous Jerry.

Jerry took his place on the show-bench and chained all right, but, in the show ring, his mistress had no control over him. He and his litter brother were competing, having outclassed all entries. Bob, Jerry's competitor, was obedient, mannerly. The Judge turned to take the red and the blue ribbons from the table, the frown of indecision not quite gone. Blue ribbon in right hand, red in left, he advanced. Jerry was flying for the far end of the ring, leash swinging. His mistress was dusting herself after a roll in the sawdust. The Judge handed the blue ribbon to Bob's master, to the hydrangea lady he gave the red. Bob's master fixed the blue to Bob's collar, the red ribbon dangled in the limp hand of Jerry's mistress. She did not care whether its redness fell among the sawdust and was lost or not—her Jerry was beaten! ✗

SEPTEMBER:

MOULTING MOONTH
FOR THOSE FOOL PARROTS
AND FEATHERS STICKING TO
EVERYTHING;
MISSUS FUSSING OVER
AND PAMPERING THE DISGUST-
ING FOULS WITH ALL SORTS
OF DAINTIES:
HER AFFECTION FOR THOSE
JABBERING CREATURES IS
THE ONLY FLAW I KNOW
OF IN MY MISSUSES
CHARACTER.

Decision

Punk in his prime was siring magnificent puppies, but I had to think forward. Punk and Loo, the founders of my kennel, would one day have to be replaced by young stock. Bobbies are a long-lived breed. Kennel sires and matrons, however, must not be over old if the aim of the kennel is to produce vigorous working stock. It was time I thought about rearing a young pair to carry on.

I had a beautiful puppy, a son of Punk's, named David. I had also a fine upstanding puppy of about the same age that I had imported from the prairies and named Adam. In points there was little to choose between the youngsters, both were excellent specimens and promised well. I watched their development with interest. The pups were entirely different in disposition; they were great chums. David was gentle, calm—Adam bold, rollicking. David's doggy brain worked slow and steady. Adam was spontaneous—all fire. He had long legs and could jump a five-foot fence with great ease. If Adam

did not know my exact whereabouts he leapt and came to find me; David lay by the gate patiently waiting, eyes and ears alert for the least hint.

From early puppyhood Adam dominated David; not that David was in any way a weakling, but he adored Adam and obeyed him. Their pens were adjacent. At feeding time Adam bolted his dinner and then came to the dividing partition. David, a slower eater, was only half through his meal, but when Adam came and stood looking through the bars, David pushed his own food dish, nosing it close to Adam's pen. Adam shoved a paw under the boards and clawed the dish through to finish the food that was David's. This happened day after day; there was deliberate uncanny understanding between the two dogs—David always giving, Adam always taking.

One day I was housecleaning and could not have too many dogs under my feet. I shut them all into the play-field, all except David who lay on the lawn quietly watching my coming and going. Young Adam leapt the fence in search of me. Taking him to the far field I chained him and chained Eve at his side for company.

When it began to rain I was too busy to notice, and by the time I went into the garden to shake some rugs everything was soaking wet.

"Oh, poor Adam and Eve!" I exclaimed. "Chained in the open without shelter!"

I went to put them into the shed. To my amazement I found Adam and Eve each cuddled down on to a comfortable warm rug. It was queer for I knew these rugs had been hanging on a line in the basement. While I wondered I heard a chuckle from the porch of a downstair flat.

"David did it," laughed my tenant. "I watched him. The chained dogs got restive in the wet. David went up to Adam. I saw him regard the chained pup. He then went to Eve, snuffed at her wet coat and turned back into the basement. Next thing I saw was David dragging the rug to Adam who lay down upon it. Then he went back and fetched the other rug for Eve. That David is uncanny!"

Yet for all David's wisdom Adam was the dominant character of the two. Both dogs possessed admirable traits for a kennel sire. I could not decide which to keep. At last the day came—the thing had to be faced.

I built a crate and furnished it with food and water. I took the buyer's letter from my pocket; my hand trembled as I printed the man's name on the crate. I did not know which dog was going, which one would stay. I read the letter again; either pup would meet the man's requirements "Young, healthy, well-bred."

I leant over the gate watching the dogs at play in the field. David

saw me, came, snuffed at my trouble through the bars, thrust a loving tongue out to lick joy back into me.

"David, I cannot let you go!"

"Adam," I called, "Adam!" But my voice was low, uncertain.

Adam was romping with Eve and did not heed.

Common sense came hanging over the gate beside me and, looking through my eyes, said, "David is of Punk's siring. Adam's new blood would be best for the kennel." My face sank, buried itself in David's wool.

"Dog ready?" The Express Company's van was at the gate. The man waited to lift the crate. The two loose boards, the hammer, the nails were ready, everything was ready, everything but my decision.

"Hurry! We have that boat to make!"

I opened the field gate. David rushed through, jumped into the crate. I nailed the loose boards over David. Adam still romped in the field with Eve.

"David! David!" ✗

OCTOBER SPORTING MONTH
TAKES MISSUS AND I ALL OUR
TIME SHE WITH TRAPS ME WITH
JAWS TO KEEP DOWN THE MICE
THEY COME IN NOW FOR THE
WINTER AND RELY FOR SUSTIN-
ENCE ON THE PARROT GIRLS
SEED TINS; IT DOES SEEM

A GREAT WASTE TO PUT
GOOD CHEESE IN THE TRAPS
FOR THE LITTLE VERMIN:
I WENT TO EAT IT ONE DAY
AND THE TRAP SNAPPED AND
CAUGHT ME BY THE BEARD
THOUGHT I WERE DEAD!
SPRING CHICKENS JUST IN

THEIR PRIME IN OCTOBER

Loo

Loo reached me first, her motherliness, always on the alert to comfort anything, pup or human, that needed protection.

I had watched someone die that night. It was the month of February and a bitter freeze-up—ground white and hard, trees brittle. The sick woman had finished with seeing, hearing and knowing; she had breathed laboriously. In the middle of the night she had died, stopped living as a blown-out candle stops flaming. With professional calm the nurse had closed her eyes and mouth as if they had been the doors of an empty cupboard.

When it was nearly dawn I went through bitter cold and half-light back to my apartment-house. It was too early to let the Bobbies out, but I wanted the comfort of them so I freed them into the garden, accepting their loving. Warmth and cosiness sprang from the pens when I opened the doors, then I went to tend my furnace. As I stooped

to shovel coal, a man's heavy hand struck me across the face. A tenant living in one of my flats bellowed over me, "I'll teach you to let my pipes freeze!"

The shovel clanked from my hand—I reeled, fell on the coal pile. I had not seen the man follow me into the basement. Before I righted myself the man was gone, leaving the basement door open. Icy wind poured in. I sprang to slam the door, bolt the brute out. He was on the step, his hand lifted to strike me again. Quick as lightning I turned on the tap with hose attached at the basement door and directed the icy water full into his face; it washed the spectacles from his nose. Too choked, too furious, too wet even to roar, he turned and raced to his flat upstairs. I waited for his door to shut, then I ran into the garden, ran to the Bobbies.

The eagerness of Loo's rush to help me knocked me down. I did not get up, but lay on the hard snow path, my smarting cheek against its cold. Loo stood over me wanting to lick my hurt. I struck at her for a clumsy brute—told her to go away. The amazed dog shrank back. Punk and the rest crowded round; Loo, shamed and pitiful, crept behind the lilac bush. When I saw her crestfallen, broken-hearted, peeping from behind the bush, great shame filled me. A bully had struck his landlady. I had

struck Loo whom I loved; Loo, symbolizing motherliness, most nearly divine of all loves, who had rushed to comfort me.

"Loo! Loo!"

She came, her forgiving as wholehearted as her loving. I buried my face in her shaggy warmth, feeling unworthy, utterly unworthy.

"Work is breaking me, Loo!"

The dog licked my hands and face.

But the apartment-house must be run; it was my living. The kennel? . . . I had supplied the Bobtail market. For the present the kennel was but expense. Dusting the snow off myself I went up to the studio taking Punk and Loo with me. On the table lay an open letter. A kindly woman on a farm wanted a dog—"Mother Bobtail already bred," she wrote. Giving myself no time to think I quoted Loo. Loo's chin rested on my knee as I wrote. I dared not look below my pen. Soon Loo would have another family.

"The joy of Loo in her puppies will ease her strangeness," I told myself, but—"Loo, Loo, I love you."

Remorseful, bitter—I loathed the money when it came, hated the approving nods, the words "wise," "sensible," which people stuffed

into my ears when they knew of my decision. I loathed myself, cursed the grind that broke me and took my dogs from me. Punk searched every corner for Loo. Most he searched my face. ✗

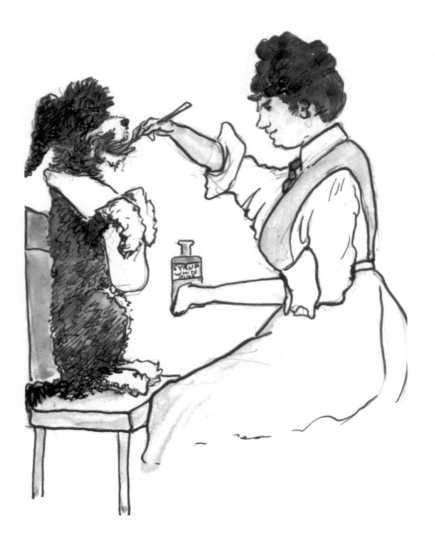

NOVEMBER

GET BAD COUGH
MISSUS OPINES ITS FOG
AND DAMP: I OPINE ITS
TOO MUCH TUBBING : GET
WHITE PINE SYRUP
THREE TIMES A DAY; ITS
NICE AND SWEET; DONT
CARE HOW LONG COUGH
STAYS, DONT WANT TO DIE
THO' CAUSE MISSUS COULD'
ENT RUN THAT STUDIO ALONE

Last of the Bobtails

Loo had been gone two days when a dowdy little woman came and held out a handful of small change.

"A guardian and companion for my daughter—delicate, city-bred, marrying a rancher on a lonely island. She dreads the loneliness while her husband is out clearing his land. I thought a sheep-dog . . . "

The price was not that of half a pup. She saw how young my puppies were and began to snivel. "It will be so long before they are protective!"

I took her small money in exchange for Punk, took it to buy value for him in her eyes. Those meagre savings meant as much to her as a big price meant to a rich person. A dog given free is not a dog valued, so I accepted her pittance.

Loo gone, Punk gone—emptying the kennel was numbness. I let every dog go—all except Adam. I would keep just one. Their going gave me more leisure, but it did not heal me. I took young Adam and

went to the Okanagan to try high air. I struck a "flu" epidemic and lay six weeks very ill in Kelowna.

They were good to Adam. He was allowed to lie beside my bed. At last we took the lake boat going to Penticton to catch the Vancouver train. The train came roaring into the station and the platform shook. Adam, unused to trains, bolted. In a jiffy he was but a speck heading for the benches above Penticton.

The station master took Adam's chain and ticket.

"Hi, Bill!" he called to a taxi-driver, "Scoot like hell! Overtake that dog. Put him aboard at the water tank two miles down the line. You can make it easy!"

At the tank no Adam was put aboard. I was forced to go on alone. I wired, wrote, advertised. All answers were the same. Adam was seen here and there, but allowed no one to come near him. A shaggy form growing gaunter ever gaunter slunk through the empty streets of Penticton at night, haunting wharf and station. Everyone knew his story, people put out food. Everyone was afraid to try catching him. At great distances a lost terrified dog with tossing coat was seen tearing across country. It was hopeless for me to go up. No one could tell me in what direction to search. Then for months no one saw him. I hoped that he was dead. Two winters and one summer passed—I got a letter

from a woman. She said, "We moved into a house some miles out of Penticton. It had been empty for a long while. We were startled to see a large shaggy animal dart from under the house. 'Adam!' I cried, 'Adam!' for I knew about the dog. He halted and looked back one second, then on, on, a mad terrified rush to get away from humans. There was a great hole under our house hollowed to fit his body," said the woman.

At night she put out food. She heard the dog snuff at the door crack. She did not alarm him by opening the door or by calling out. Adam was known the country over as "the wild dog."

One day the woman worked in her garden; something touched her. Adam was there, holding his great paw up. She wrote me, "Come and get him." But before I could start, a wire came saying, "Adam shipped."

I went into the Victoria freight shed. The tired dog was stretched in sleep.

"Adam!"

He quivered but he did not open his eyes.

"Adam!"

His nose stretched to my shoe, to my skirt—sniffing.

"Adam!"

One bound! Forepaws planted one on each of my shoulders, his tongue reaching for my face.

Everyone said, "Adam will be wild, impossible after nineteen months of freedom."

He had forgotten nothing, had acquired no evil habit. Only one torment possessed Adam—fear of ever letting me out of his sight again—Adam, the last of my Bobtails. ✗

DECEMBER.
 XMAS AND
MORE DINNER THAN
I CAN CONSUME!
EVEN I, MYSELF.

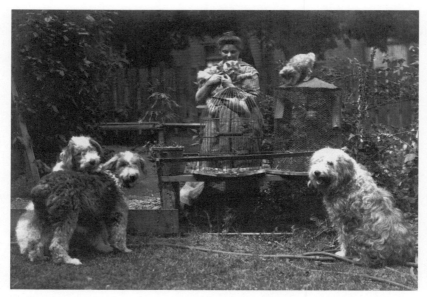

Emily Carr, circa 1918, in the garden of her house in Victoria, British Columbia. She is with some of her many pets: three sheep dogs, two cats, a parrot and a chipmunk. *British Columbia Archives HP51747*